First there was *Graffiti Lives, OK,* a best-seller from Scotland to Sydney. Now the highways and byways from Land's End to LA, from Scunthorpe to the Simpson Desert have been combed to gather together an even richer harvest of the world's best and funniest graffiti. The result: *Graffiti 2* - a new collection of over four hundred of the choicest scribblings and daubings, certain to amuse and entertain you. Nigel Rees, who has compiled both books, has become synonymous with graffiti, as the example from the West of England reproduced on the front cover of this book reveals!

NIGEL REES

GRAFFITI 2

London

UNWIN PAPERBACKS

Boston Sydney

First published in Unwin Paperbacks 1980
Reprinted 1980 (Five times), 1981

UNWIN® PAPERBACKS
40 Museum Street, London WC1A 1LU

This edition ©Nigel Rees Productions
Ltd, 1980

British Library Cataloguing in Publication Data

Rees, Nigel
 Graffiti 2.
 1. Graffiti
 I. Title
 001.55 GT3912 80-40355

ISBN 0-04-827023-7

Art Director David Pocknell
Design Michael Cavers
Cover David Pocknell

Typeset in 10pt Times Compugraphic
by Hawkins Graphics Ltd
Printed in Great Britain by
The Anchor Press Ltd, Tiptree, Essex

Mark my words, when a society has to resort to the lavatory for its humour, the writing is on the wall.

Alan Bennett,
Forty Years On

Lo, when the wall is fallen, shall it not be said unto you, Where is the daubing wherewith ye have daubed it?

Ezekiel 13:12

First there was *Graffiti Lives, OK*. Then, lo! we scoured the highways and the byways from Land's End to L.A., from Scunthorpe to the Simpson Desert. The result: *Graffiti 2* -four hundred more of the choicest scribblings and daubings for your entertainment.

Graffiti writers, by the nature of their calling, are anonymous. Yet I still get asked, 'Who are they?' With the funnier and wittier scrawls there is a lot in common between writing graffiti and telling jokes. Perhaps the graffiti writer is a shy joke teller. He 'tells' his joke on a wall and runs away without waiting for a response.

The best graffiti, however, convey a type of humour you won't find in quite the same form anywhere else, least of all spoken. What often generates it is an element of protest or frustration -at official bossiness, at the cocksure claims of advertisers, and at the unremitting exercise of Sod's Law in every area of human existence. But behind it there is an - often good-humoured - acceptance of the fact that you can't change anything and that writing on a wall is the only way left to vent your feelings.

But as long as there has been writing on the wall there have been people complaining about it. In Thomas Hardy's *The Return of the Native* (describing a

rural area in the mid-Nineteenth Century) we read:

'Ah, there's too much of that sending to school these days! It only does harm. Every gatepost and barn's door you come to is sure to have some bad word or other chalked upon it by young rascals: a woman can hardly pass for shame sometimes . . .'

Indeed, when the 1870 Education Act was being debated it was suggested that improving education would only result in more graffiti, written *lower down.*

By collecting graffiti in books like this and by drawing attention to them in my BBC radio programme *'Quote . . . Unquote'* and my Granada TV quiz *Cabbages and Kings,* I lay myself open to letters like this:

'As the practice of scrawling graffiti is only a brand of the vandalism which our society should be doing far more to discourage and eliminate, I implore you not to quote any of it, however witty and amusing it may seem. Surely the method by which it is expressed, i.e. by defacing either public or private property, immediately cancels out its rare cleverness. And to quote such wit will but serve to encourage the idiots (be they clever or simple) who practise it.'

A valid point, but, weighing the advantages and disadvantages, it is possible to take a different view. No one

with any sense wishes to encourage moronic, ugly graffiti or the disfigurement of buildings. But I suspect that most people would be willing to tolerate a certain amount of graffiti if they provide amusement and brighten up dull stretches of brick or concrete.

Besides, it is unlikely that the urge to write on walls will ever be eliminated, so the best we can do is to contain it a bit. In other words, let graffiti be written where they can easily be removed, where they don't blot the landscape - and let the graffiti be good ones. Again I must say that I have never indulged in the activity myself though I have featured *in* graffiti. I'm told that the following appeared on a wall in Wells:

I thought graffiti was a kind of pasta until I discovered Nigel Rees...

Come to think of it, I have never heard of anyone being fined or imprisoned for writing amusing graffiti, only for the other sort. But it is an offence in most countries and a particularly bad place to get caught in is Singapore. There you can be fined up to 2,000 dollars or sent to gaol for three years, in either

case laying yourself open to between three and eight strokes of the cane (they are very precise about these matters in Singapore).

Is graffiti-writing on the increase? I suppose the answer is Yes. Thanks to the introduction of paint in aerosol cans and felt-tipped pens, it is not the laborious activity it once was. But it is also probably becoming wittier and is no longer merely the preoccupation of morons with or without a message. For example, although I have seen in London

TEENAGE TEARAWAYS WHO LOVE GRAFFITI RULE OK

the 'so and so rules, OK' type of graffiti has been taken up by clever folk and been subjected to numerous inventive variations -many of which you will find in this book.

Is there any difference between men's and women's graffiti? Researching the answer presents certain difficulties - of attribution and access! However, women seem to have a tendency to write lengthier graffiti and to be even more preoccupied than men with sex. A few years ago, a survey was carried out comparing graffiti in adjacent men's and women's lavatories in the Students' Union at Leeds University. Women students had

written three times as much as men, though this was largely because they went in for long paragraphs, where for men a sentence would do.

Women's graffiti were also held to be less funny. This is not because women have no sense of humour but because they are less given to joke-telling than men. And, if a good deal of writing on lavatory walls is alcohol-induced, that may explain why women pen more cries for help. Alcohol tends to depress them, make them a bit maudlin, whereas on men it may have a more stimulating effect.

How have I gone about collecting the graffiti presented here? If you go graffiti-hunting, you will probably be disappointed. It is best to rely on good old serendipity to provide you with the choicest examples. And I have been helped by countless people who have rushed to share with me the jokes they have found or heard about. Listeners and viewers send me material (even when they know it is not suitable for public airing) -adding a new dimension to the sharing process which prompted the graffiti-writer to do his thing in the first place.

So far as the graffiti included in this book are concerned, where a place name follows an example, that merely indicates a sighting. The graffito may well occur elsewhere. When

a graffito has been added (to a notice, advertisement or another graffito) you will find the original in capitals - and the addition printed after a dash. Also, I have supplied dates where necessary.

'For heaven's sake don't mention my name or address,' implored one of the people who contributed a graffito included in this book. 'I am known in this tiny hamlet as a staid elderly lady. Just call me "a listener in Gloucestershire".'

Well, 'listener in Gloucestershire', clever graffiti-writers or sharp-eyed graffiti-spotters, whoever you are, wherever you are - thank you!

Nigel Rees

GRAFFITI 2

In the beginning was the word.
And the word was 'Aardvark'.

Abandon hope - Pandora took
the money.

Stratford-upon-Avon

Absolute zero is cool.

Wimbledon

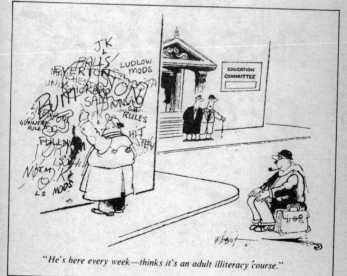

"He's here every week—thinks it's an adult illiteracy course."

KINDLY ADJUST YOUR
DRESS BEFORE LEAVING
- as a refusal often offends.

ISAAC
NEWTON
WAS RIGHT
+ THIS <u>IS</u>
THE CENTRE
OF GRAFFITI

GOD LOVES YOU
- so does the vicar.

*gents' lavatory,
Cricklade*

Calling all animals lovers! We wish to inform you that your habits are illegal.

OK, so I'm cured of schizophrenia, but where am I now when I need me?

Manchester University

Doris Archer is a prude.

Crouch End

Not enough is being done for the apathetic.

Clifton, Bristol

I couldn't care less about apathy.

GRAFFITI 2

We buy junk and sell antiques.

*written in dust on
old van*

ANARCHY NOW
- pay later.

*Oxford Circus
Underground
Station*

Put the anal back into analysis.

Manchester

I'D GIVE MY RIGHT ARM
TO BE AMBIDEXTROUS
- you can have mine, I'm
left-handed

DAVE ALLEN FOR POPE

*Wolverhampton,
after death of
Pope Paul, 1978*

DAVE ALLEN FOR POPE
THIS TIME

*after death of
Pope John Paul I*

GRAFFITI 2

~~ALGÉRIE FRANÇAISE~~
~~ALGÉRIE ALGÉRIENNE~~
~~ALGÉRIE FRANÇAISE~~
~~ALGÉRIE ALGÉRIENNE~~
~~ALGÉRIE FRANÇAISE~~
ALGÉRIE ALGÉRIENNE

Why can't you bloody frogs
make up your bloody minds!

Paris, early 1960s

DID YOU KNOW
SPIRO AGNEW IS AN
ANAGRAM OF
'GROW A PENIS'?

*Edinburgh
University*

ACCOUNTING FOR
WOMEN
- there's no accounting for
women.

*poster in London
Underground*

WHAT MADE ELIZABETH
ARDEN?
- when Max Factor.

Folkestone

17

THE ARMY BUILDS MEN
- build me one, Veronica.

recruiting poster

My Uncle Fred died of
asbestosis - it took six months to
cremate the poor devil.

Southsea

Observation astronomique
- trois heures de Vénus, trois ans
de Mercure.

Geneva

Whither atrophy?

Deptford

AVENUE ROAD
- what's wrong with the old one
then?

Want a quick time, long time, companionship, black leather bondage? Ring Maggie and Maureen, Edinburgh ★ ★ ★ ★ (Mourning only) *(sic)*

> *phone booth,*
> *Princes Street*

Pam Ayres is Eddie Waring in drag.

$$x^2 \sqrt{K. \sin 0.01 x}$$

Sycophancy rules - if it's OK by you.

> *Hambleden*

STOP THE BAATH TERROR IN IRAQ
- have a shower.

> *Oxford Circus*
> *Underground*
> *station*

IF YOU SEE AN UNATTENDED BAG
- go up and talk to her.

> *ditto*

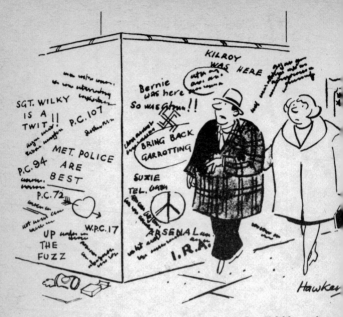

"What are the police doing about it, that's what I'd like to know

Please do not ask for bail, as a
refusal often offends.

> *in the dock,*
> *Willesden*
> *Magistrates Court*

8 OUT OF EVERY 10 MEN
WRITE WITH A BALL-POINT
PEN
- what do the other two do
with it?

*I*s a lady barrister without
her briefs a solicitor?

> *University College,*
> *London*

EAT MORE BEANS - AMERICA NEEDS GAS

> *US*

*B*eethoven was so deaf, he
thought he was a painter.

> *Inter-City train,*
> *Newcastle-*
> *Sheffield*

*W*hen Bernadette takes hers
down, we'll take ours down.

> *Loyalist slogan,*
> *York Road,*
> *Belfast, about*
> *removal of*
> *barricades*

The best things in life are duty free.

Heathrow airport

I bet you I could stop gambling.

Sydney

Men call us birds. Is that because we pick up worms?

Oxford

Christmas comes but once a year
Thank God I'm not Christmas.

Luton

Bisexual man, aged 30, seeks young married couple.

Dresden

But you'd look sweet upon the seat of a bisexual made for two.

Scots rule, och aye!

Carlisle

Blackheads go down well in Hackney.

Goldsmiths College, London

Someday my boat will come in -and with my luck I'll be at the airport.

Blessed Mary, we believe
That without sin thou didst
conceive.
Holy Virgin, thus believing,
May we sin without conceiving?

Edinburgh University

That'll teach you to make lumpy custard.

*speech balloon
added to poster
for film* The Blue
Max *which
showed German
pilot shooting
down fighter plane*

KEEP THE BOAT PEOPLE OUT
- sink the Irish ferry.

Bristol, 1979

What Katy Did
What Katy Did With A Shetland
 Pony
Katy And Her Foal

Biggles Flies Open
Biggles Does a Jigsaw Puzzle
Biggles Falls Over
Biggles Translates Nietszche

If the human brain was simple
enough for us to understand
we'd be so simple we couldn't.

Eat bran and the world will
fall out of your bottom.

Sheffield

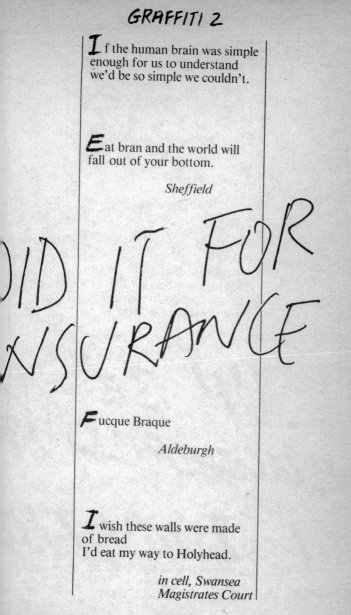

ID IT FOR
NSURANCE

Fucque Braque

Aldeburgh

I wish these walls were made
of bread
I'd eat my way to Holyhead.

*in cell, Swansea
Magistrates Court*

Bread is the staff of life
Toast a decadent capitalist
luxury.

on bakery wall

I can't breathe.

London

A Britannia is better than a
Trident, because four screws
always beat three blow-jobs.

Gatwick airport

I'll BE
BUGGERED IF
I JOIN THE

BRITISH RAIL ADVISE
THAT THIS RIGHT OF WAY
IS NOT DEDICATED TO THE
PUBLIC
- neither is British Rail.

COME THE REVOLUTION,
BRITISH RAIL WILL BE THE
FIRST TO GO
- if they arrive on time.

Fleet, Hampshire

George Brown for God.

*Ringwood,
Hampshire*

Bruggle strothers.

Cardiff University

Hampstead, 1979

27

Burgess loves Maclean.

> *reputedly written
> on a wall in
> Moscow by the
> actor Ernest
> Thesiger while on
> an Old Vic tour,
> 1950s*

KINDLY PASS ALONG THE
 BUS
AND SO MAKE ROOM FOR
 ALL OF US

> *London Transport
> poster*

- That's all right without a doubt
But how the hell do we get out?

LET BUSES PULL OUT

> *sign on bus*

- and help reduce the minibus
population.

MAKE SOMEONE HAPPY.
- strangle Buzby.

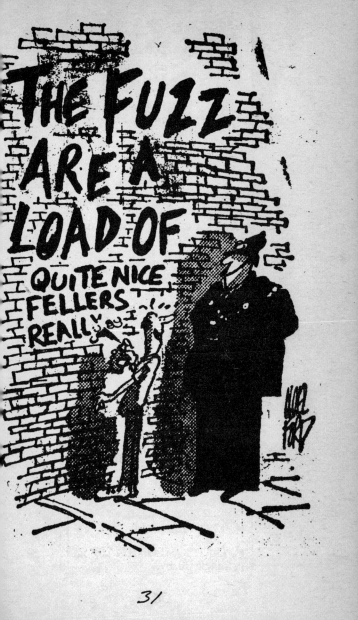

STREAKER YOUR END

THINK!

Wayside Pulpit

- or thwim.

THINK!

ditto

- thoap.

Free the Indianapolis 500.

Man needs God like a goldfish needs a motorbike.

Faculty of Theology, King's College, London

EWARE

SIGHT

Los Angeles

Jesus shaves.

on Gillette ad

Free the Chiltern Hundreds.

Sex is all right but it's not as good as the real thing.

Hexham

It takes 51 Irishmen to write on a wall. One to hold the pen and the other 50 to move the wall.

Bristol University

WALLS HAVE EARS
- I've just discovered one in my
ice cream.

Lapworth,
Warwickshire

CASTRATE RAPISTS
- *have a ball.*

London
Underground

Schizophrenia RULES, OK, OK.

I GOT MY JOB THROUGH
THE NEW YORK TIMES
- so did Castro.

Cats like plain crisps.

Deptford

CAUTION AIR BRAKES

> *on lorry seen in
> Oxford, changed
> to:*

- caution tea brakes.

Man is born free but
everywhere is in chains.
Smash the cistern.

> *Bristol University*

Don't study medicine and law
at the same time, it tries your
patients.

> *Birmingham
> Medical School*

Where's the bloody chalk then?

> *carved on
> blackboard
> supplied for
> graffiti in Barnet
> pub*

CHELSEA
ARE
MAGIC

— WATCH THEM
DISAPPEAR FROM
THE FIRST
DIVISION

*C*yril Chaos is 25.

Bath

*C*hastity is its own punishment.

*High Holborn,
London*

*J*esus Christ is alive and well and signing copies of the Bible at Foyle's.

*W*hy go to Burton's? Let the local CID stitch you up.

*I*t is now beyond any doubt that cigarettes are the biggest cause of statistics.

I thought cirrhosis was a type of cloud, until I discovered Smirnoff.

The Louvre, Paris

Sceptics may or may not rule, OK.

THE WORLD IS FLAT.
CLASS OF 1491.
- all the girls in our world are flat. Class of 1973.

Princeton

CLEANLINESS IS NEXT TO GODLINESS
- only in an Irish dictionary.

You are never alone with a clone

Aldershot

Proposed site for coat hook.

indicated by small circle on back of lavatory door, Ashford

Descartes thought he was here.

Coito ergo sum.

*Army and Navy
Stores, London*

Sale this week - three pulls,
half a crown.

*on train
communication
cord*

I USED TO BE
CONCEITED -
BUT NOW I'M
BSOLUTELY
PERFECT

Dartford

GRAFFITI 2

ASSIST THE CONDUCTOR, GIVE THE RIGHT CHANGE

notice in Bournemouth bus, changed to:

- Amaze the conductor, give the right change.

If you're not confused, you're misinformed.

Bartlett School of Architecture, London University

Constipation is the thief of time. Diarrhoea waits for no man.

Let them eat Corgi.

Hammersmith, during Jubilee Year bread strike

Living in Coventry is about as interesting as watching a plank warp

Coventry

DO NOT THROW TOOTHPICKS IN HERE.
THE CRABS CAN POLE VAULT.

The Rubaiyat rules, OK.

University Library, Cambridge

JESUS CHRIST IS COMING

on railway bridge over obscure branch line in Yorkshire

- only if he remembers to change at Darlington.

Save fuel. Get cremated with a friend.

Liverpool

THE CREMATION OF MR
_____ WILL TAKE
PLACE AT GOLDERS GREEN
CREMATORIUM AT 2.30
- please put him on a low gas.
Can't get there till 4.

*Covent Garden,
London*

Nationalise crime and make sure it doesn't pay.

Henley

Crime doesn't pay, but the hours are good.

*Staines police
station*

GOD IS BLACK
- yes, she is.

Cunnilingus is a real tongue-twister.

*Maryport,
Cumbria*

If Typhoo put the T in BRITAIN who put the CUNT in SCUNTHORPE?

*comprehensive
school, Sussex*

dandruff
is
tasteless

London

Don't laugh. It might be your daughter in here.

*in dust on passion
wagon*

WHAT ARE YOUR
CHANCES OF GETTING
PREGNANT TONIGHT?

*family planning
poster*

- chance would be a fine thing.

George Davis is ~~innos~~
~~innoss~~
guilty

WOMEN
RECLAIM
NIG

Dead people are cool.

Death is hereditary.

Coventry

KEEP DEATH OFF THE
ROADS
- drive on the pavement.

Palmers Green

TO MY FATHER AND
MOTHER

*dedication in
learned textbook
on jurisprudence*

- thanks, son, it's just what we
wanted.

Remember the truth dentist.

SUPPORT WOMEN'S LIB
- use his razor.

Royce Rolls, KO

DON'T BUY THIS CHEWING
GUM, IT TASTES OF
RUBBER
- yes, but it lasts all day.

*on contraceptive
vending machine*

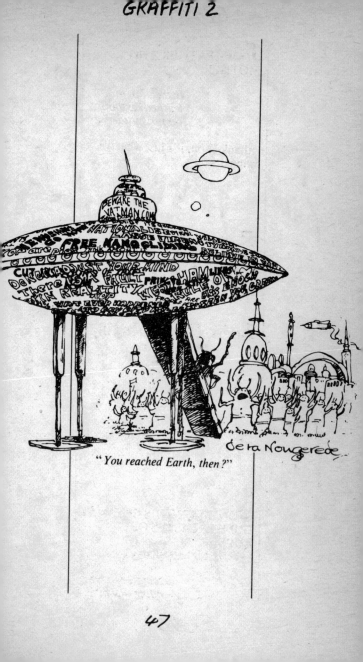

"You reached Earth, then?"

de ra Nougerede

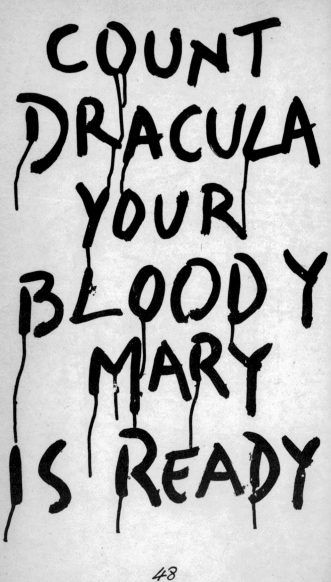

COUNT
DRACULA
YOUR
BLOODY
MARY
IS READY

GRAFFITI 2

*T*his woman degrades adverts.

*D*isembowelling takes some guts

> *Coventry*

*B*eware of the doc.

> *outside vet's,*
> *Sidmouth*

*P*LEASE ADJUST
YOUR DRESS
BEFORE LEAVING
- I don't wear one.

> *gents' lavatory,*
> *Old Trafford*

*G*LORY TO GOD IN THE
HIGH ST

> *church poster,*
> *altered*

DO YOU HAVE A DRINK
PROBLEM?
- yes, I can't afford it.

Fit Dunlops and be satisfied.

> *addition to*
> *contraceptive ad,*
> *Hereford*

Easter is cancelled this year.
They've found the body.

> *Chicago*

So has Christmas.They've found
the father.

> *Newcastle*
> *University*

Why don't you give Elgin his
marbles back?

> *British Museum*

Procrastination will rule one day, OK?

Graffiti should be obscene and not heard.

MILLWALL
- brick wall
- Max Wall

Deptford

Like a nice time, dearie?
Phone 123.

phone booth

WHAT YOU SHOULD
DO IF THE
THAMES FLOODS
- breast-stroke.

*Moorgate
Underground
station*

*E*LVIS LIVES
- and they've buried the poor
bugger!

*Holborn
Underground
station*

SAVE
ENERGY—
BE
APATHETIC
YOU KNOW
IT MAKES
SENSE

*Mornington
Crescent, London*

Yesterday I couldn't spell engineer. Now I are one.

Loughborough University

EUNUCHS UNITE— YOU HAVE NOTHING TO LOSE

Avoid the end of the year rush —fail your exams now.

London teaching hospital

Examinations—Nature's laxative

City of London Polytechnic

Is this the face that shipped a thousand lunches?

> *over mirror in*
> *hotel much used*
> *by business*
> *clientele,*
> *Gloucester*

Fart for peace.

> *Hammersmith*

A fate worse than death is better than dying.

> *Dublin*

I used to think Fellatio was a character in Hamlet until I discovered Smirnoff.

Guy Fawkes was the sanest man who ever went into the Houses of Parliament - and look what happened to him.

POTASSIUM
EXTHOXIDE
RULES

C_2H_5OK .

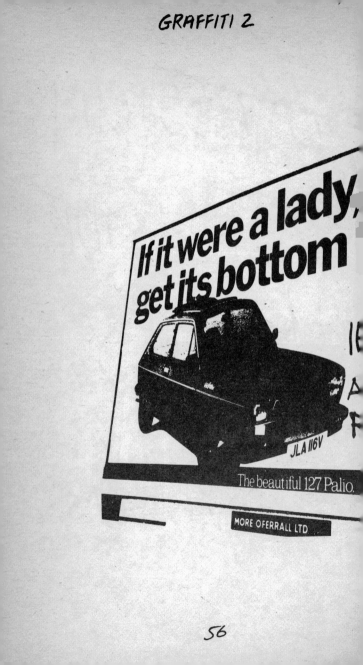

vould
ched.

WOMAN WAS
SHE WOULD
OU DOWN!
FIAT

I never used to be able to finish anything, but now I

Stinky Finkelstine cannot adjust to his environment.

New York City

Old fishermen never die - they just smell that way.

There was a young man in
Florence
To whom all art was abhorrence
So he got slightly tipsy,
Went to the Uffizi,
And peed on the paintings in
torrents.

The Uffizi,
Florence

SAY IT WITH
FLOWERS - GIVE Hi
A TRIFFID

Oxford

Wallace Ford (1897-1966) was a British-born film actor who went to Hollywood in the early 1930s and after playing a number of near-leading roles was cast mostly as a supporting character actor. On his grave was the epitaph, 'At last I get top billing'. But someone wrote above his name: Clark Gable and Myrna Loy, supported by . . .

*F*REE ASTRID PROLL
- no, thank you, I've got two
already.

*W*hat kind of fuel am I.

> *written in dust on*
> *oil tanker lorry*

PERSONAL
PROBLEMS
RULE, B.O.

Hornchurch

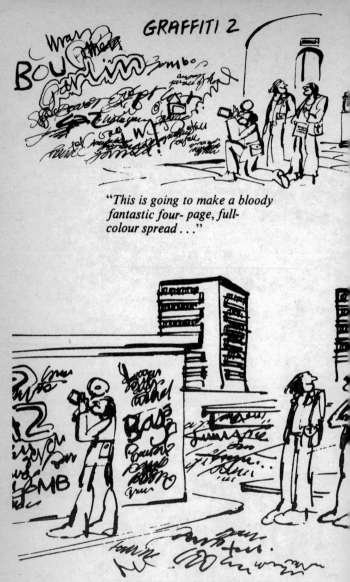

"This is going to make a bloody fantastic four- page, full-colour spread . . ."

". . . graffiti, the new art-form of the underprivileged masses . . ."

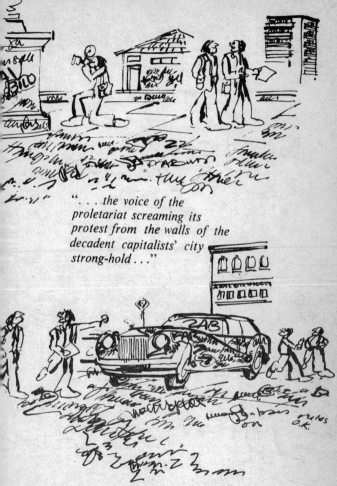

"... the voice of the proletariat screaming its protest from the walls of the decadent capitalists' city strong-hold ..."

"Look at that, all over our car, the dirty little bastards!"

All men eat but Fu Manchu.

Israel

GBH really scrolls your nurd.

Norwich

Donald Coggan
Cheats at Scrabble

Canterbury

P-P-Patrick Campbell
Ru..Ru..Ru..Rules

Yorick is a numb skull.

Stratford-upon-Avon

De Gaulle est pire qu'Hitler.
Mais plus con.

Orly

I have nothing to declare but my genes.

*G*eography is everywhere.

> Bedworth,
> Warwickshire

*E*lvis rocks in his box.

> Hungerford
> Bridge, London

*I*t's time they gave George VII a go.

GERMAN
SHEPHERDS
CAN BE FUN
MRS ROBINSON

Pedants rule, OK - or, more
accurately, exhibit certain of the
trappings of traditional
leadership.

Watford

God made animals, great and
 small,
Some that slither and some that
 crawl -
And Rochester police employ
 them all.

Strood

If you feel strongly about
graffiti, sign a partition.

Bray

BRING BACK THE GOONS
- I was unaware the Goons had
gone.

Perth, Scotland

If the enemy is not giving up, destroy him. GORKI.

> *Soviet Union,*
> *WWII*

If the friend is not giving up, destroy him.

> *Moscow, after*
> *invasion of*
> *Czechoslovakia,*
> *1968*

Grass is Mother Nature's way of saying 'High!'

> *Radcliffe Station,*
> *Manchester*

Peter Hain for Queen.

> *St Pancras*
> *Station, London*

Halitosis is better than no breath at all.

The trouble with God is he thinks
he's Peter Hall.

National Theatre,
London

The hamburgers in this establishment have been endorsed on TV by Sir Robert Mark.

LIDING

SEBALL

YCLING

Sheffield

No hand signals - the driver of this vehicle is a convicted Arab shoplifter.

The hangman let us down.

Luton

HAPPINESS IS A WARM EARPIECE
- yes, but ecstasy is a warm codpiece.

telephone ad, Ravenscourt Park

The hatchback of Notre Dame.

in dust on Renault car seen in Strathclyde

50 years and this is all I get.

speech balloon coming out of Warren Beatty's mouth on poster for Heaven Can Wait *in which he is shown as an angel looking at a gold watch, Chalk Farm Underground station, London*

A RULES, COKEY.

Hook Norton Ale reaches the parts Heineken daren't mention.

Hereford

Heteros go homo.

Paris

WHAT DO YOU HAVE IN COMMON WITH YOUR HUSBAND?

ad for series in women's magazines

- we were both married on the same day.

A fertile imagination is no compensation for vasectomy.

Melbourne

My wife wears black rubber gear and whips me, Ohhhh Kay!

Bristol

Let's keep incest in the family.

Sausalito

Indian driver - smoke signals only.

lorry on M1

ILLITERATES WATCH THIS SPACE

DUE TO INDUSTRIAL ACTION THIS TOILET WILL BE CLOSED ALL DAY ON MONDAY
- please do all you can today.

My inferiority complexes aren't as good as yours.

Wellington

Beat inflation - steal.

Hastings

EVERY WEEKDAY 25 INTER-CITY TRAINS LEAVE SOUTHAMPTON

British Rail poster

- Only Seven Get Back

*I*MPORTANT NOTICE.WILL
ALL TRAVELLERS VISITING
IRAN PLEASE VISIT THE
BRITISH EMBASSY
IMMEDIATELY ON
ARRIVAL

*poster at
Heathrow aiport*

- and then go next door to the
psychiatrist.

I like it and him in that order.

*ladies lavatory,
Blackpool*

*J*ack is nimble
Jack is quick
But Jill prefers
The candlestick.

traditional

*J*AWS 3
- just when you thought it was
safe to go to the toilet.

HOW LABOUR WILL COPE

poster

- next week, how to nail jelly to the ceiling.

I wanted to be a judge but they found out my Mum and Dad was married.

cell under court

Mañuel rules, Oh-¿Qué?

Fawlty Towers

LORD DENNING RULES, OK
- House of Lord overrules, OK.

Emmanuel Kant but Genghis Khan.

British Museum

This is an Oxford college. Think of it more as a Fair Isle sweater.

Keble College,
Oxford

Here lies the grave of Keelin
And on it his wife is kneelin;
If he were alive she would be
 lying,
And he would be kneeling.

Dublin,
traditional

$$B4 \; i \sqrt{u} \; \frac{RU}{16} \, ?$$

Ayatollah Khomeini is a Shiite.

PLEASE DO NOT DEFACE THESE WALLS
- Killjoy is here.

've run out of tapes.
 Krapp.

Exeter

*T*his door is now in its second
edition.

> *on newly-
> decorated,
> previously graffiti-
> strewn door,
> Monash
> University,
> Melbourne*

*T*he views expressed on this wall
are not necessarily those of the
Aberystwyth Urban District
Council.

80% OF BISHOPS TAKE *THE
TIMES*

the other 20% buy it.

*W*omen in labour keep capital
in power.

Oxford

LABOUR IS THE ANSWER
- if Labour is the answer, it's a
bloody silly question.

He may have hairs on his chest
-but, sister, so has Lassie.

*ladies' lavatory,
Bristol*

Here did I lay my Celia down.
I got the pox and she got half
a crown.

*scratched on
window, Chancery
Lane, London,
1719*

Definition of a lecture: a means
of transferring information from
the notes of the lecturer to the
notes of the student without
passing through the minds of
either.

*Warwick
University*

You will never walk alone with schizophrenia.

In a survey carried out to see what men liked about women's legs, 27% said they preferred women with fat legs and 15% said they preferred women with thin legs. The remaining 58% said they preferred something in between.

Reading

Vote Liberal - or we'll shoot your dog.

London, 1978

Liberals are a Labour-saving device.

London School of Economics, 1978

Vote Liberal - and feel a man.

Cambridge

Don't worry, Liddle Towers
-they'll probably name a block of
flats after you.

*Manchester
University*

$$\text{Life} = \int_{\text{Birth}}^{\text{Death}} \mathcal{L}(\text{Happiness}).dt \; *$$

Richard the Lion-Heart is alive
and well and asking Christian
Barnard for his money back.

Life is a sexually transmitted
disease.

Lancaster

*Life is an integral function of
happiness over the time between
birth and death.

THE FIRST THREE MINUTES
OF LIFE CAN BE THE MOST
DANGEROUS

hospital notice

- the last three minutes are pretty
dodgy, too.

DO NOT USE LIFT IN CASE
OF FIRE
- just jump.

Cardiff

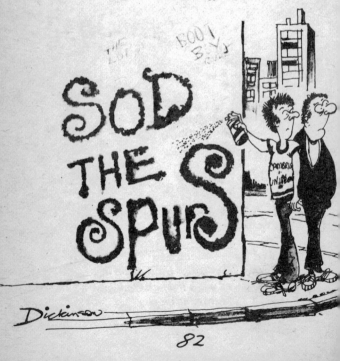

*W*ould the last person to leave the country please switch off the lights.

*J*argon rules, ongoing agreement situation.

*I*F THIS MACHINE IS OUT OF ORDER SEE THE LANDLORD

> *on contraceptive vending machine*

- and if it's in order, see the barmaid.

"Fantastic! Do it again in red and I'll do an Omnibus programme on you."

I choked Linda Lovelace.

WARNING. PASSENGERS
ARE REQUESTED NOT TO
CROSS THE LINES
- it takes hours to untangle them
afterwards.

Warrington

Beware the Irish limbo dancer.

*written by gap at
top of lavatory
door*

I'd rather have a full bottle in
front of me than a full frontal
lobotomy.

*Leicester
University*

Logic is on heat.

Belfast

London Pride don't want cheap publicity.

painted on hoarding, Ealing

Keep London tidy - eat a pigeon a day.

ISTIANS O

Roman amphitheatre, Trier

Bob Harris is a loudmouth.

Worthing

Until I discovered women, I thought love was a pain up the arse.

Hatfield
Polytechnic

MAKE LOVE, NOT WAR

I'm married, I do both.

GRAFFITI 2

LORD LUCAN WAS HERE
- no I wasn't.

Bad spellers of the world, untie!

> *Southgate*
> *Underground*
> *station*

Norman Mailer is the master of the single entendre.

Make magic not tea.

> *Strood*

Thank God, a man at last.

> *on lifting seat in*
> *lavatory, Girton*
> *College,*
> *Cambridge*

What lot of cunning linguists you all are.

> *at foot of graffiti-strewn wall*

Marriage is a wonderful institution - but who wants to live in an institution?

MASTURBATION STUNTS THE GROWTH

> *eight feet from the floor:*

- Liar!

One thing about masturbation -you don't have to look your best.

Another thing about masturbation - you meet a better class of person.

GRAFFITI 2

If God had not meant us to
write on walls, he would never
have given us the example.

Exeter

Can we have a new wall.

*at foot of graffiti-
strewn wall,
Holborn*

MAX HEADROOM
- is cool.

Orpington

Free the ITV Seven.

Only the mediocre are always
at their best.

*Hyde Park,
London*

MERSEY DOCKS AND
HARBOUR BOARD
- and little lambs eat ivy*.

Hurlingham rules, croquet.

Mickey Mouse is a rat.

Bishop's Castle

How do girls get minks? - the
same way minks get minks.

Moking is not a health hazard.

*in dust on Mini-
Moke*

*A popular Second World War
song went: 'Mares eat oats and
does eat oats / And little lambs
eat ivy.'

Monogamy leaves a lot to be desired.

Monkey is the route to all people.

University of East Anglia

DESIGNED BY COMPUTER
SILENCED BY LASER
BUILT BY ROBOT

Fiat Strada ad

- driven by moron.

Mary Poppins is a junkie.

FREE COLLECTIVE
BARGAINING
- he's innocent.

Oxford

Flower | Power Rules, bougar

*I*S MUFFIN THE MULE A
SEXUAL OFFENCE?
- no, but you might get Moby
Dick.

Sussex University

*N*apoleon Out.

*on Martello tower,
near Dublin*

I've half a mind to join the
National Front. That's all I'll
need.

Highbury

*G*OD IS NOT DEAD
- merely out to lunch.

*Gonville and Caius College,
Cambridge, has three gates
inscribed 'Honoris', 'Virtutis'
and 'Humilitatis'. A more recent
inscription over the archway
leading to the Gents reads:*

Necessitatis.

GRAFFITI 2

Horse power rules, neigh neigh.

*Beverley race
course*

Nervous breakdowns are
hereditary - we get them from
our children.

Neurotics build castles in the air.
Psychotics live in them.
Psychiatrists charge the rent.

*Birmingham
University*

This vehicle is powered by Olivia
Newton-John's knicker elastic.

*on lorry seen in
East London*

Dick Nixon before he dicks you.

Bergen

Vote Nixon - why change Dicks in the middle of a screw?

Israel

Nkrumah for Queen.

Cambridge

Norman Hunter bites your leg.
Norman Scott bites your pillow.

What ever did we do before we discovered nostalgia?

NOTHING ACTS FASTER
THAN ANADIN
- then take nothing instead.

Covent Garden

Nye weeps for Labour.

Caerphilly

Repent ye, for the kingdom of Bevan is Nye.

*Northampton
1959 General
Election*

Definition of a nymphomaniac: a girl who trips you up and is under you before you hit the floor.

*Warwick
University*

DORIS IS A NYMPHO MANIAC
- sadly not true

Leighton Buzzard

French diplomats rule, au Quai.

*Keble College,
Oxford*

QEDIP

A NER

ORAL SEX IS
A MATTE

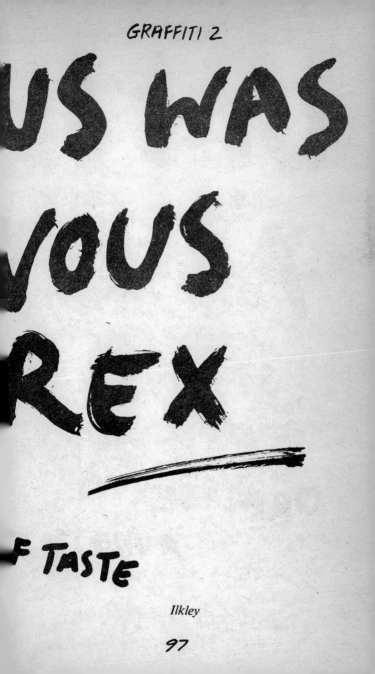

US WAS

VOUS

REX

F TASTE

Ilkley

God will give your whole body an orgasm when you die if you spend your life in divine foreplay.

Where is Lee Harvey Oswald now that his country needs him?

during Watergate

DOESN'T ANYONE OR ANYTHING WORK ROUND HERE?

on 'Out of Order' sign on Post Office stamp machine

- yes, I do. I put up the 'Out of Order' signs.

MAKE CHILDREN HAPPY - support paedophilia.

London WC1

Panic now and avoid the end of term rush.

Essex University

Just because you're paranoid, it doesn't mean they're not out to get you.

Kardomah cafe ladies' lavatory, Nottingham

We are the people our parents warned us about.

Harrogate

Patrons are requested to remain seated throughout the performance.

gents' lavatory, Leominster

Don't waste water - pee on a friend.

Looe (really)

PEEK ABOO!

An erection is like the Theory of Relativity - the more you think about it, the harder it gets.

Victoria Station, London

PENIS ANGELICUS
- Anus Mirabilis.

A PHONE CALL. IT COSTS LESS THAN YOU THINK
- soon it'll cost more than you'll believe.

It'll never get well If you picket

hospital, Ilfracombe

Pigeons eat crisps.

London NW1

IS A CASTRATED PIG DISGRUNTLED

Manchester

I'm pink therefore I'm spam.

Arrange the following words into a well-known phrase or saying: OFF PISS.

I thought Plato was a Greek washing-up liquid.

Bodleian Library, Oxford

Please don't touch me
Please don't touch
Please don't
Please do
Please
Ohhhh!

> *Chalk Farm*
> *Underground*
> *station, London*

Help you local police force -
beat yourself up.

The philosopher Amnaeus
Seneca is the only Roman writer
to condemn the bloody games.

> *Pompeii, AD 79*

What lasts longer? A Pope or a
wine-gum?

> *Glasgow, 1978*

Keep the Pope off the moon.

> *Belfast*

Not so much a pleasure
More a sense of joy:
I got to the liver
Before Portnoy.

*Leicester School
of Education*

PRAYER MEETING AT 7.30
ON WEDNESDAYS.
REFRESHMENTS PROVIDED
AFTERWARDS
- come to pray, stay to scoff.

Birkenhead

PRESERVE
WILDLIFE —
PICKLE A
SQUIRREL

Being employed by this firm is
like making love to a hedgehog
-one prick working against
thousands.

Birmingham

Procreation is the thief of time.

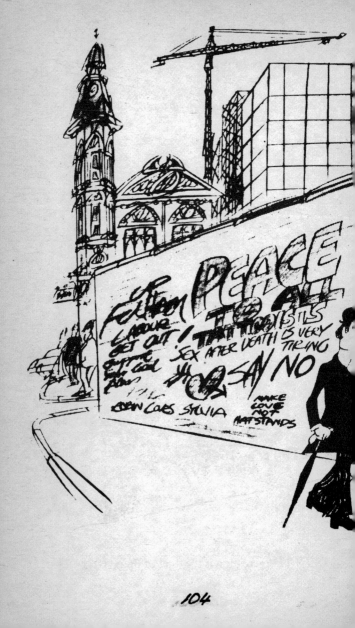

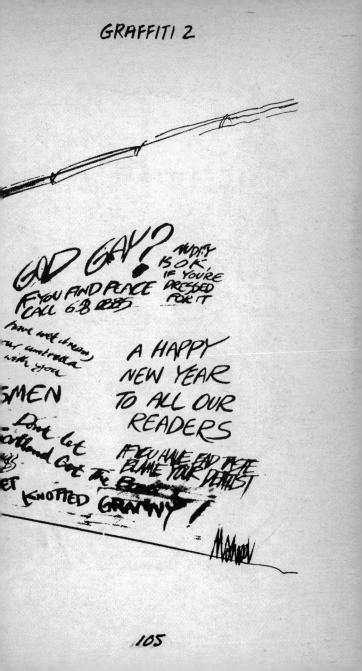

GOD GAY?

NUDITY IS O.K. IF YOU'RE DRESSED FOR IT

IF YOU FIND PEACE CALL 68 0885

have wet dreams our umbrella with you

...SMEN

A HAPPY
NEW YEAR
TO ALL OUR
READERS

Don't let ...tland Get The ...ET KNOTTED GRANNY!

IF YOU HAVE BAD TEETH BLAME YOUR DENTIST

Marcel Proust is a yenta.

New York City

Start a new movement - eat a prune.

How much longer must our lives be dominated by Prussian horse-cripplers, a puerile debating society, and nebbishes from cobweb corner? Let us found a new nation under God.

How do you tell the sex of a chromosome? By taking down its genes.

Oxford

The only safe fast-breeder is a rabbit. Say 'No' to nuclear power.

Sussex University

GRAFFITI 2

READING MAKETH A FULL MAN; CONFERENCE A READY MAN; AND WRITING AN EXACT MAN
- BACON
- a fat man

added to library inscription, Liverpool

A lavatory wall at a university had recently been whitewashed. Within days, someone had divided up the wall into three columns for future graffiti, marked 'Sport', 'Politics' and 'Sexual Deviations'. After another day, somebody else had written under each heading:

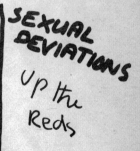

SPORT	POLITICS	SEXUAL DEVIATIONS
Up the Reds	Up the Reds	Up the Reds

Satisfaction guaranteed - or double your refuse refunded.

on dustcart, Cwmbran, Gwent

REINCARNATION IS
MAKING A COMEBACK
- over my dead body.

Billingsgate

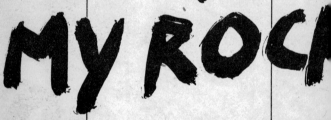

Jack the Ripper lives - he works in our laundry.

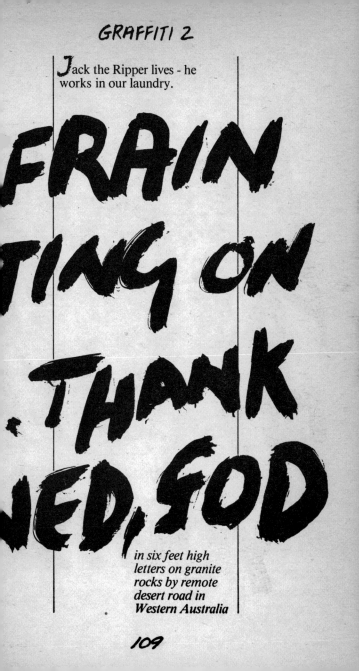

FRAIN
TING ON
.THANK
NED, GOD

in six feet high letters on granite rocks by remote desert road in Western Australia

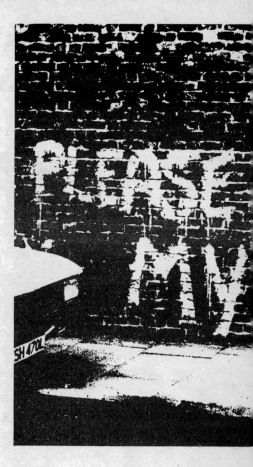

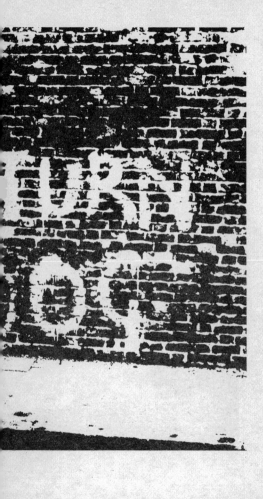

If you have looked as far as this, you must be looking for something. Why not try the Roman Catholic church?

graffito written high up on lavatory wall, Oxford

IN 1066, NEAR THIS CHURCH, THE NORMANS LANDED AND WERE REPELLED BY THE MEN OF ROMNEY
- so am I.

on notice, Romney parish church

Roses are red
Violets are blue;
Why can't black
Be beautiful, too?

Roses are red
Violet's are blue
And mine are white.

*S*ado-masochism means not having to say your are sorry.

*S*alvation Army kick to kill.

New Malden

*O*h, Lord above, send down a dove
With wings as sharp as razors
To cut the throats of those who try
To lower textile wages.

Huddersfield mill, 1930s

*W*HY NO GRAFFITI?
- we're working to rule, OK

*T*his is an art form. Stop council vandals ruining it.

*D*avid Frost drools, OK

I thought a sell-out was the end of a special offer until I discovered the National Union of Railwaymen.

in guard's carriage, London Underground train

*D*o not accuse me of being anti-semantic. Some of my best friends are words.

Hammersmith

*S*EX IS BAD FOR ONE
- but it's very good for two.

LIKE CAVI
A TREAT.
IT AROUN

You're never alone if you're a sex-maniac

Hatfield

MORT AU SHAH
- et aux souris.

Paris, 1979

DOWN WITH THE FASCIST
SHAH OF IRAN
- 's trousers.

Hull

RE, SEX IS
ON'T SPREAD
LIKE
MARMALADE.

*Middlesex
Polytechnic*

CONSIDERATION
RULES,
IF THATS
OK

Cornwall

SHAKESPEARE WAS A TRANSVESTITE
- I should know, sailor! Signed, Anne Hathaway (Mr).

Stratford-upon-Avon

THERE'S A SHORTAGE OF GIRLS IN OXFORD
- I don't care how short they are, there just aren't enough of them.

SOFT SHOULDERS
- warm thighs.

road sign, Ormskirk

Ignore this sign.

Los Angeles

Himmler seeks similar.
Indian gentleman seeks Simla.
Gay Nepali seeks Himalaya.

*Harrogate Royal
Baths*

DON'T SPIT
YOU
MIGHT NEED
IT

*in middle of
Simpson Desert,
Australia*

The only difference between
Frank Sinatra and Walt Disney is
that Frank signs and Walt disne.

Leeds

It begins when you sink into his
arms; and ends with your arms in
his sink.

Cambridge

118

*I*f you can't stop - smile as you go under.

*on back of large
articulated lorry*

*S*mile, they said, life could be worse. So I did and it was.

*Thatchers Arms,
Norton Heath,
Essex*

I used to play football for Scotland until I discovered Smirnoff.

*N*O SMOKING IN BED
- and no sleeping in ashtrays.

USAF base

*I*t's quicker by snail.

*on British Rail
poster*

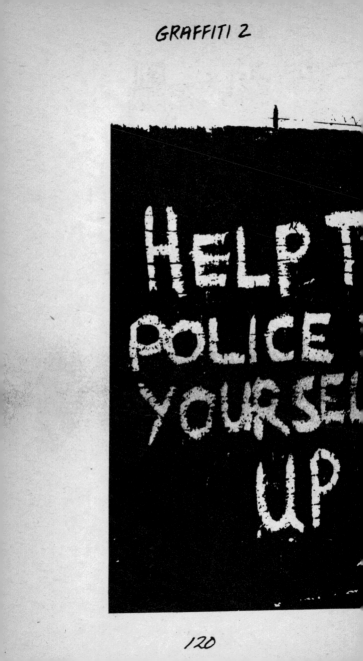

*T*his has as much to do with socialism as Cyril Smith has to do with hang-gliding.

> *on poster*
> *proclaiming*
> *Labour Party*
> *policy,*
> *London N8*

*S*ocialism is the opiate of the proletariat.

> *King's College,*
> *London*

*Y*ou've got to sock a picket or two.

*F*OUND: ONE PAIR OF GLASSES
- please write larger, I've lost my glasses.

> *BBC Engineering*
> *Training College*

GRAFFITI 2

Kenny fucks spiders.

Western Australia

SPITTING PROHIBITED
- use the Manchester Ship Canal

bus notice,
Manchester

THE REV. CHARLES
SPURGEON DEPARTED FOR
HEAVEN AT 6.30 AM TODAY
- 10.45 am. Not yet arrived.
Getting anxious, Peter.

notice,
Metropolitan
Tabernacle,
London, 1892

What do you think of Stainer's
Cruxifixion? - A very good idea.

Royal College of
Music

Stamp out quicksand.

Don't flatter yourself - stand nearer.

> *gents' lavatory,*
> *Sydney*

Sterility is hereditary.

> *Swansea*

When straining, please refrain from gnawing the woodwork.

> *gents' lavatory,*
> *Prestatyn*

Streak - or for ever hold your piece.

> *Brighton*

JAMES BOND RULES OOK

Brunel rules, IK.

*on Western
Region Class 50
locomotive*

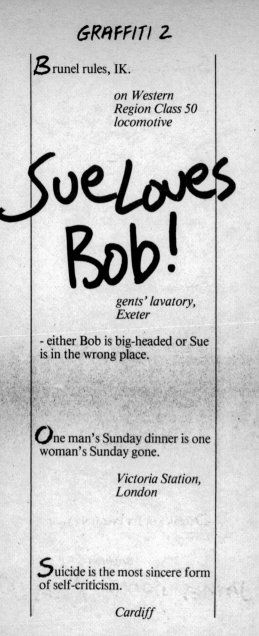

Sue Loves Bob!

*gents' lavatory,
Exeter*

- either Bob is big-headed or Sue
is in the wrong place.

One man's Sunday dinner is one
woman's Sunday gone.

*Victoria Station,
London*

Suicide is the most sincere form
of self-criticism.

Cardiff

It is forbidden to throw
tantrums on the line.

*Pimlico
Underground
Station, London*

Help Tasmanian afforestation -
plant an acorn upside down.

*Cambridge,
England*

Tea is more artistic than coffee

Mill Hill

Those who can, do - those who
can't, teach - and those who
can't teach lecture on the
sociology of education degrees.

*Middlesex
Polytechnic*

Other vice may be nice, but sex
won't rot your teeth.

*dental hospital,
London*

PLEASE DON'T WRITE ON WALLS
- you want maybe we should type?

Vote TGWU at the next General Election and cut out the middle man.

Croydon, 1979

MARGARET THATCHER SHOULD BE P.M.
- yes, permanently muzzled.

Sheffield

Get Maggie Thatcher before she gets . . . ugh . . .

Exeter

THE GRAFFITI IN THIS PUB IS TERRIBLE
- so is the shepherd's pie.

*F*ree the Inter-City 125.

Paddington

*O*n baffling wall-map of flyovers and tunnels, during reconstruction of Liverpool city centre, someone had added: Throw six to start.

*T*ime flies like knives, fruit flies like bananas.

Corsham

*N*ever mind the Titanic - is there any news of the iceberg?

- WORLDS FIRST SEE - THROUGH TOILET

Keele University

Owing to lack of interest, tomorrow has been cancelled.

*Wisconsin
University*

TOURISTS. YES
TROOPS NO

Dublin

ADVANCE TOWELMASTER
- and be recognised.

Anarchy, no rules, OK?

Kentish Town

MORE FEMALE TRAIN
DRIVERS
- a woman's right to choo-choose

*Hampstead Heath
station*

GRAFFITI 2

I AM A PRACTISING
TRANSVESTITE ON
HOLIDAY HERE TILL NEXT
WEEK. IF YOU WOULD LIKE
TO MEET ME I WILL BE
HERE AT 7.30 EACH NIGHT
- how will I recognise you?

> *Welsh seaside
> resort*

O, weary traveller, do not weep
They are not dead - just fast
asleep.

> *scribbled on
> restaurant menu,
> Irish Republic*

*I*s John Travolta the new
Eminence Grease?

*A*lice Trout moves mysteriously.

BEAT UNEMPLOYMENT
-VOTE LABOUR
- Vote Conservative and treat it
nicely.

Corby

Fight unemployment - waste
police time.

If you can do joined up, real
writing, you too can be a union
leader.

Canvey Island

UNORFADOX.

Blackwall Tunnel

May all your ups and downs be
in bed.

Reno, Nevada

Yea, though I walk through the valley of death I will fear no evil, for I am the biggest son of a bitch in the valley.

I am a vampire. Please wash your neck.

> *gents' lavatory,*
> *Manchester*

A *few years ago, Birmingham carried out an anti-vandalism campaign. Someone helping to spread the message had removed the small mosaic links from the mural in a city subway so that is read:*
HELP STOP THE VANDAL

Anagrams - or luke?

Pavlov's Dogs rule.